AN
Asylum
OF
Loons

Charming Names
from the
Bird World

Adventure Publications
Cambridge, Minnesota

Cover design by Travis Bryant

Edited by Claire Suer

Photos used under license from Shutterstock.com:
Front Cover: *(Clockwise starting at upper left corner)*
1) Litvalifa: Cattail **2) Wolfgang Kruck:** Red-throated diver **3) V. Belov:** Red-throated Loon looking down **4) cramnosnhoj:** Common Loon looking down **5) Agnieszka Bacal:** Loon feather **6) Sam Chow:** Loon fluttering **7) Litvalifa:** Green grass **8) Sam Chow:** Loon head **9) Agnieszka Bacal:** Loon fluttering **10) Vectorpocket:** Feather (center)

Back Cover: Boyce's Images: American Goldfinch (left) **FotoRequest:** American Goldfinch (right)

A.S.Floro: 45 **Adam Fichna:** 58 **aDam Wildlife:** 21, 34 **Agnieszka Bacal:** 37 **Alberto Loyo:** 12 **asharkyu:** 73 **Bildagentur Zoonar GmbH:** 77 **Birdiegal:** 50 **Bonnie Taylor Barry:** 14 **Brian A Wolf:** 51 **Brian E Kushner:** 44 **Butterfly Hunter:** 16 **D. Longenbaugh:** 40 **david scott dodd:** 74, 75 **Dennis Jacobsen:** 23, 31 **Dennis W Donohue:** 34-35 **DMS Foto:** 52 **Edgloris Marys:** 69 **Eric Isselee:** 36 **FotoRequest:** 11, 35 **Frank Fichtmueller:** 7 **Glass and Nature:** 46 **Horst Widlewski:** 42, 43 **Images by Dr. Alan Lipkin:** 55 **Ivan Godal:** 76 **Jeff W. Jarrett:** 63 **JeremyRichards:** 8 **Jim Nelson:** 48 **jo Crebbin:** 56 **John Carnemolla:** 26 **Joshua Raif:** 60 **KzlKurt:** 70 **Lux Blue:** 62 **Marcos Amend:** 38 **Marius Dobilas:** 24 **Menno Schaefer:** 68 **MH STOCK:** 18 **moosehenderson:** 72 **Myriam Keogh:** 4 **Ondrej Prosicky:** 19, 28 **Peter Gudella:** 17 **photonewman:** 15 **rock ptarmigan:** 59 **Simonas Minkevicius:** 65 **Steve Boer:** 33 **Super Prin:** 49 **Tathoms:** 53 **The Perfect:** 30 **Tim Zurowski:** 41 **vagabond54:** 10 **valleyboi63:** 22 **Victor Suarez Naranjo:** 9 **Vishnevskiy Vasily:** 64 **Wildlife World:** 20 **William Eugene Dummitt:** 67

10 9 8 7 6 5 4 3 2 1

An Asylum of Loons
Copyright © 2019 by AdventureKEEN
Published by Adventure Publications
An imprint of AdventureKEEN
330 Garfield Street South
Cambridge, Minnesota 55008
(800) 678-7006
www.adventurepublications.net
Printed in China
ISBN 978-1-59193-904-7 (hardcover); ISBN 978-1-59193-905-4 (ebook)

TABLE OF CONTENTS

Zebra Finch

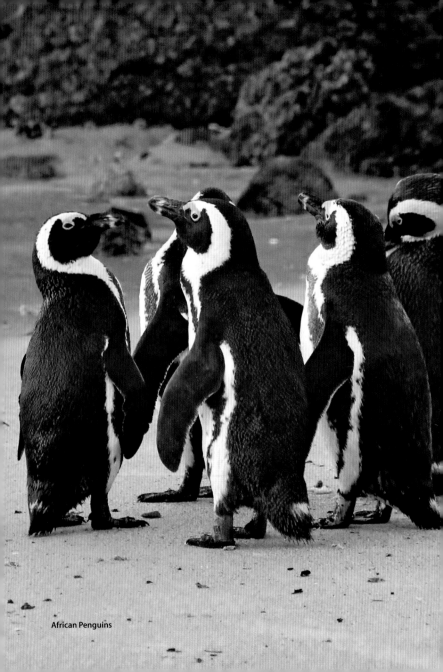
African Penguins

Group Names for Animals

One of the first quirks of language that we learn as children is that we use a different word for animals when they are found in groups. For example, a group of lions is a pride, sheep in the field are a flock, and an assemblage of fish is a school. These are called collective nouns, and most animals, including birds, have their own group names. But these names, especially for birds, aren't very well-known; after all, what do you call a group of cockatoos, or penguins, or vultures? And where did "an unkindness of ravens" come from? This is the delightful stuff this book will explore.

Collective Nouns for Animals: A Brief History

The invention of specific terms for groups of animals begins with lists of "terms of venery," part of an explosion of hunting terminology in the Late Middle Ages. While all classes of English people hunted, the aristocracy largely did so as a social pastime, not out of need. In the mid-1400s, the fashion at court was to invent, know, and use a highly specialized set of vocabulary for all kinds of game species. ("Venery," at that time, meant the hunt or the chase.) The names chosen in this aristocratic, male-dominated environment were often dramatic and reflected the power and strength of the quarry, thereby serving to stroke the egos of the hunters who subdued them. Collective names for less-dramatic prey, as well as non-game species, are often something else entirely, privileging wordplay and humor far more than the sheer drama of the hunt.

Class certainly played a big part in the development of these words: the wealthiest and highest-ranked people got to hunt certain most-desirable species and had the leisure time to learn the different terms. Likewise, not knowing all the terms of venery was a social indicator that someone was of lower class.

The Book of Saint Albans

Without question, the most famous collection of collective nouns/terms of venery was *The Book of Saint Albans*, published in 1486. Its section on hunting featured a whopping 164 terms under the heading "The Compaynys of Beestys and Fowlys." Many of the most famous and familiar collective nouns for animals originate there—as you'll see from the many references we make to it in this book.

But the words in *The Book of Saint Albans* weren't invented just for well-heeled aristocrats. There's plenty of evidence that they were created for fun. After all, the book contains references to human groups and professions. Readers must have delighted in and laughed over the cleverness of "a sentence of judges," "a boast of soldiers," or "a prudence of vicars."

A Fun Pastime

Thus an endlessly entertaining word game was born: inventing new collective nouns. Once you start trying to find the cleverest and most apt word for each bird group, it's hard to stop. Puns and alliteration and commentary on a group's behavior are all common approaches.

A Linguistic Debate

For as much fun as they are, some have turned the concept of collective nouns into a debate. On one side, there are a few grumpy folks who huffily insist that scientists don't use these words, so they should be abandoned. Writer Nicholas Lund goes so far as to call these collective nouns "morsels of linguistic candy rotting cavities into our scientific integrity"!

On the other hand, there are some folks who insist there should be an "official," agreed-upon collective noun for every species. James Lipton, author of *An Exaltation of Larks*, a modern book of terms of venery, doesn't go quite so far—but he does write about some collective nouns having validity based on their source, or being "authentic" or "correct."

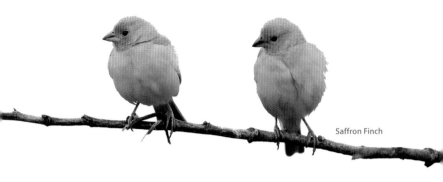
Saffron Finch

We're not sure why there is any debate at all. We encourage you to send each other clickbait articles with headings like: "Did you know a group of finches is called a charm?" We approve of all bar-trivia discussions and fanciful inventions. We think the key is to watch birds, stay playful, and have fun.

So What Is This Book?

Simple, really. We thought birders and word-lovers alike would enjoy this book of quirky collective nouns, as a "clever dictionary" of sorts. We wanted to dig a little deeper than just a list, and actually get into the reasons and history behind some of these recognized (or less-recognized) terms. We've found it fascinating that some of these collective nouns reference the sound that a bird might make, what they look like, or their characteristic behavior—or occasionally, somehow, all three! Some of these terms tell a deeper history of a species, and humanity's relationship to it, including the corresponding cultural meanings and symbolism for different birds.

Have Fun

We hope this book inspires and entertains you. If you're a bird enthusiast, perhaps you'll talk about the flocks you spot with more relish. If you're a language enthusiast, perhaps you'll learn something extra about birds, or be inspired to go on your own etymological explorations.

Most of all, we hope you enjoy the word game of adding to this list and expanding it, and sharing your findings and creations with others.

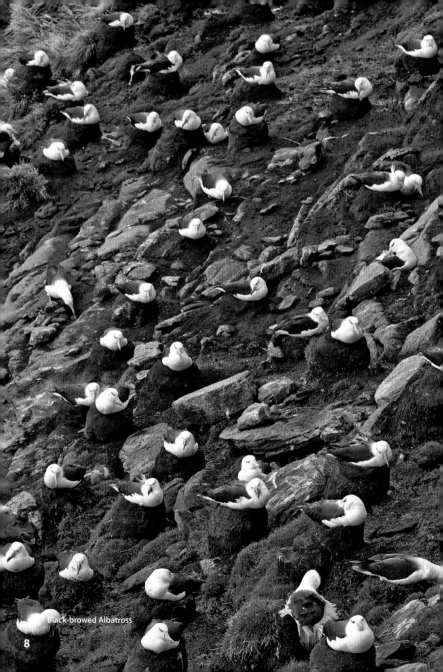
Black-browed Albatross

THE BIRDS

ALBATROSS, a rookery of . . . "Rookery" comes from the base word "rook," and as you may expect, it originally described a group of rooks' breeding nests. Today it's also used to describe groups of other birds, and occasionally even dense collections of people, as in a slum. A notable use of "rookery" to describe albatross is in Edgar Allan Poe's only completed novel, *The Narrative of Arthur Gordon Pym of Nantucket*.

AUKS, a loomery of . . . Some species of auks—e.g. guillemots—are also called looms, and the places where they flock together for breeding are known as "loomeries."

AVOCETS, an orchestra of . . . The musical collective noun "orchestra" is based on the sound of their beautiful calls when they're congregated in a colony.

BABBLERS, a brook or sisterhood of . . . Babblers are a kind of songbird common on the Indian subcontinent. Because they usually forage in groups of six to ten birds, folks in urban Northern India call them the "seven brethren," or, as translated into English by the British, "seven sisters." They probably earned "brook" from the cliché "babbling brook," describing the sound of a natural fresh stream.

Babbler

BITTERNS, a pretense or dash of . . .

American
Bittern

More secretive than other members of the heron family, bitterns' stealthy, standing-still hunting behavior may have earned them "pretense." The meaning behind the collective noun "dash" is less clear, but it does suggest hasty or sudden movements, much like a bittern makes when it finally does move. Or, someone was mixing up a cocktail with a "dash of bitters" and liked the wordplay. See also Herons.

BLACKBIRDS, a cloud, cluster, or merle of . . .

What else to call the sight of a swirling mass of flying blackbirds, tightly wound together as if flying with a hive mind, but a "cloud"? Well, you could use *merle*, a Scottish word for blackbird (used mainly in Scottish poetry).

BLUE JAYS, a band, party, or scold of . . .

See Jays.

BOBOLINKS, a chain of . . .

The folks who first named this bird wrote down an approximation of its call: "Bob Lincoln." There were many variations; Washington Irving called this bird "the luxurious little boblin-con." Over time, the name became standardized as "bobolink," and as we know, many links make a "chain."

BOBWHITES, a name dropping of . . .

This one might be a reference to the way "bobwhite" sounds like a person's name. (Some famous Bob White's were politicians and businessmen.) See also Quail.

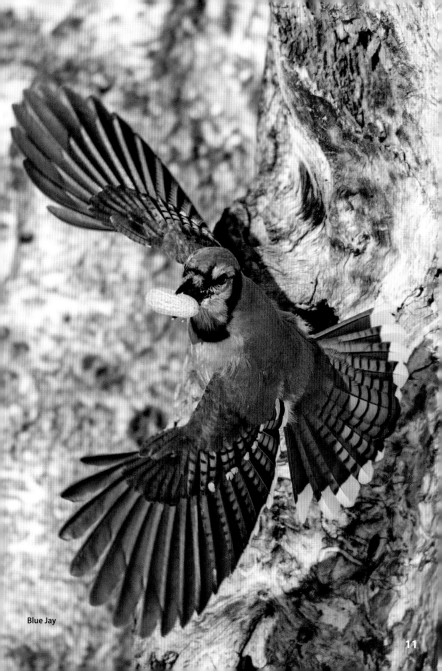
Blue Jay

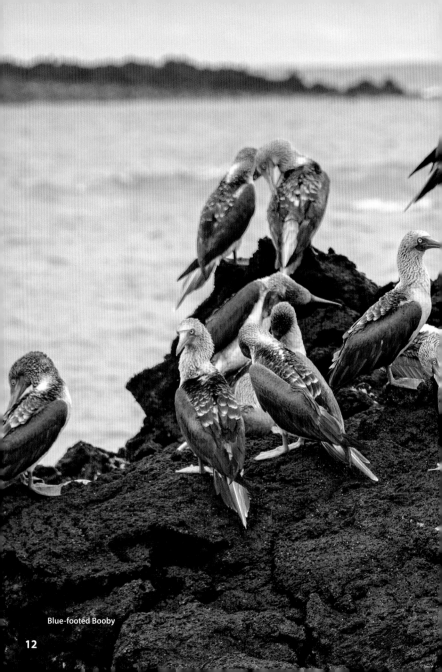

Blue-footed Booby

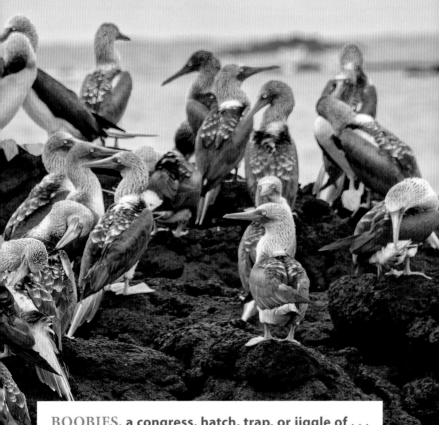

BOOBIES, a congress, hatch, trap, or jiggle of . . .

The oldest meanings of "booby" were all about calling someone stupid or a dunce, and presumably this is the humor behind the collective noun "congress." "Hatch" and "trap" come from the common compound phrases "booby hatch" (a small hatch in the weather deck of a merchant ship) and "booby trap" (a harmless-looking object containing an explosive or other trap). The most conspicuous current slang meaning of "booby" results in some other off-color suggestions for a collective noun for these sea birds; "jiggle" is as far as we'll go in that direction here.

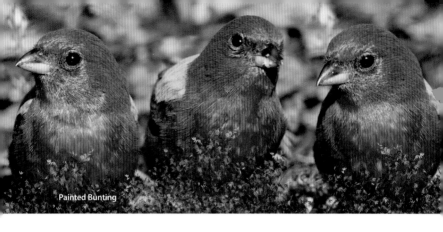
Painted Bunting

BUFFLEHEADS, a baffle or duffel bag of . . . The bulbous heads of these sea ducks earned them the "buffalo" reference in their name; from there, punning and wordplay on "buffle" have led to the confusing "baffle" and the cylindrical "duffel bag." See also Ducks.

BULLFINCHES, a bellow or bellowing of . . . A bellow is the roar of a bull, so this is likely a play on the "bull" in "bullfinch."

BUNTINGS, a mural, decoration, or palette of . . . These collective nouns all refer to how buntings display distinctive, beautiful, and sometimes incredibly colorful plumage. In particular, the painted bunting's radiant blue, green, and red patches call to mind the bright palette of a mural painter.

BUZZARDS, a wake of . . . See Vultures.

CANARIES, an opera or aria of . . . Canaries are trainable singers—in fact, in the slang of organized crime, a "canary" is someone who "sings" to the police. So a group of these singers may indeed produce an "opera"!

CANVASBACKS, an awning or sail of . . . Awnings and sails are made of canvas, hence the play on these ducks' name. See also Ducks.

CARDINALS, a college, conclave, radiance, or Vatican of . . . The collective noun "college" was established early on, and it's certainly named for the College of Cardinals of the Catholic Church, which elects the Pope. The "conclave" is the private meeting in which they vote.

CATBIRDS, a mewing or mews of . . . Catbirds got their name from their distinctive call, which sounds like a cat's meow.

CHICKADEES, a banditry or dissimulation of . . .
See Titmice.

CHICKENS, a brood, clutch, or peep of . . . "Brood" is a word for offspring of animals that lay eggs—not just chickens but also snakes and insects. ("Brood" became a verb, from the way hens sit on eggs, and later, humorously, acquired the meanings "to hover over" and "to meditate moodily over," so that humans might brood as much as chickens do.) A

"clutch" was first used to describe the claws of a bird or beast of prey, and from there to mean human hands in their cruelest uses, but later it also came to be a synonym for a brood of chickens. "Peep," the feeble sound of a chick, was one of the collective nouns listed in *The Book of Saint Albans*: "a Pepe of chykennys."

Rooster

CHIFFCHAFFS, **a confusion of . . .** These warblers' chirpy call gave them both their onomatopoeic name and the disordered, commotion-filled collective noun "confusion." People have also often literally confused them for willow warblers, a very similar species. See also Warblers.

CHOUGHS, **a chatter or chattering of . . .**
The Book of Saint Albans dubbed these birds a "chattering" after their noisiness. It's said that King Arthur did not die but was turned into a red-billed chough; if he returns, as legend says he will, we'll see if he's a chatterbox.

COCKATOOS, **a crackle of . . .** The raspy call of a cockatoo might be said to "crackle," or perhaps the sulphur-crested cockatoo's yellow crest reminded someone of a flame. Or maybe this was one of those collective nouns that took hold just because it sounds cute!

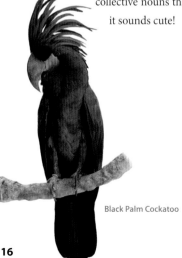

Black Palm Cockatoo

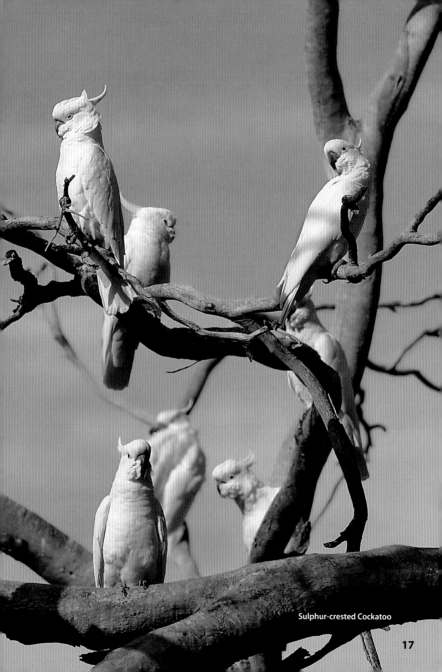

Sulphur-crested Cockatoo

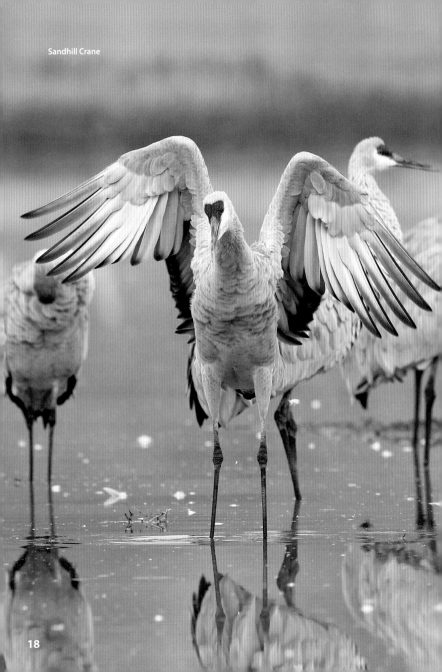

Sandhill Crane

COOTS, a commotion or cover of . . . These small water birds have a distinctive loud call, hence "commotion"; perhaps "cover" is associated with the prominent frontal shields that coots sport on their foreheads.

CORMORANTS, a gulp or embarrassment of . . .

Cormorants tend to "gulp" down a large amount of fish daily. But "gulp" might have been chosen as a behavior of an embarrassed person—"embarrassment" itself is also used as a collective noun for the red-faced cormorant in particular.

Neotropic Cormorant

COWBIRDS, a herd or corral of . . . Cowbirds accompany herds of cattle in order to eat the large number of insects stirred up by the cattle, which is how they got their name. As such, they've earned the general (and very old) collective noun "herd," which is more often used for cattle and bovine domestic animals. Similarly, "corral" comes from the enclosures people use for cows.

CRANES, a herd of . . . "Herd" is a collective noun not used as often for birds as for cows and bovine animals, but using "herd" for a group of cranes goes all the way back to *The Book of Saint Albans*, where it was among the first on the list ("an Herde of Cranys").

CREEPERS, **a spiral of . . .** These little birds creep their way up a tree with a hopping motion that can result in a "spiral" around the trunk. Also, during the pursuits of mating season, male creepers fly in fast spirals.

Red Crossbill

CROSSBILLS, **a crookedness or warp of . . .** It's the "crookedness" of a crossbill's strange beak that allows this bird to shear apart the scales of a pinecone and access the seeds, its source of food—much like a "warped" pair of scissors.

CROWS, **a murder, horde, or cauldron of . . .** One of the more famous collective nouns, "murder" as used for a group of crows goes back to around 1475, according to the Oxford English Dictionary. As with other scavenger birds, crows' tendency to feed on rotting bodies associates them with death and has left them with negative connotations among humans. Perhaps their presence on body-strewn battlefields earned them "horde," a term originally used for a plundering, warring nomadic tribe. Cauldron is a much less-used term, perhaps a lighter association with cats, witches, and Halloween.

CUCKOOS, **an incredulity or asylum of . . .** The name "cuckoo" is an onomatopoeia of its call, and is found in early sources such as Chaucer's *Parlement of Foules* in the fourteenth century. The female cuckoo's habit of laying its eggs in other birds' nests then led to the origin of the word "cuckold"—a derisive term for any male unknowingly raising another male's offspring (and later generalized to mean any husband with an unfaithful wife). Supposedly, the man who learns his wife has cheated on him is incredulous—hence "incredulity" as the playful, clever collective noun for these

birds. Meanwhile, the use of "cuckoo" as an American slang description of a "crazy person" didn't occur until the 1920s, so "asylum" as a collective noun was created much later.

CURLEWS, a herd or curfew of . . . Like cranes and wrens, curlews were among the few birds honored with "herd," a term usually meant for bovine animals, and only given to a few of the birds and animals in *The Book of Saint Albans*. As James Lipton points out in his book on collective nouns, *An Exaltation of Larks*, using "herd" is "unacceptably dull in such an imaginative list"—which may be why curlews have also earned "curfew," a playful, obvious near-homonym.

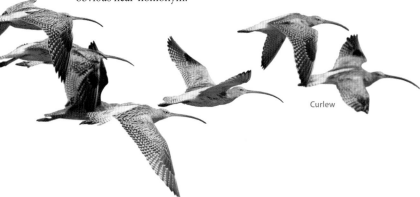

Curlew

DODOES, an extinction of . . . This collective noun, like many in this book, was born of a word game rather than a desire to know what to call an actual group of birds. We know this for sure because "extinction" of course names the dodo's fate, and perhaps reminds us of our responsibility as humans, since it was human intervention, and the animals that we inadvertently introduced, that irrevocably changed the dodo's habitat. Since the 1800s, the dodo has been used as a symbol of the dangers of extinction.

DOTTERELS, a trip of . . . These birds nest in a small hollow or scrape in the ground, where you may be likely to "trip" over them. See also Plovers.

DOVES, a dole, true love, or pitying of . . . As doves' soft coo has long been associated with mourning, it's perhaps no surprise that when English borrowed the French word for mourning, *deuil*, and morphed it into "dule" or "dole," this was the chosen collective noun for doves. Doves are also often associated with purity and piety—the latter word is the root of the word "pity." In other instances, doves are seen as symbols of faithfulness, hence "true love." Since early lists of terms of venery referred to these birds as either doves or turtledoves, we get alliterative versions on those lists, like this: "A Trewloue of Turtuldowys."

DUCKS, a paddling, badling, raft, team, or safe . . . Ducks have earned a host of collective nouns, including different nouns depending on where the group of ducks has been sighted. In the water, they're a "paddling" or "raft," or the oft-copied misspelling of paddling: "badling." On land, they are a "safe," perhaps reflecting humans' attitudes

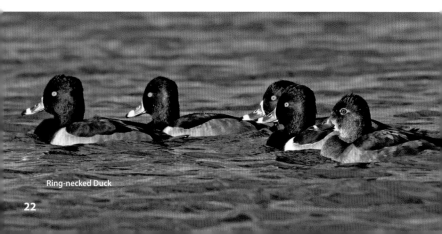

Ring-necked Duck

toward land and water more than ducks'. And in flight, ducks are a "team," a word that in its original Germanic sense meant "offspring" and was used particularly for ducklings. The earliest uses of "team" as a collective noun for a group of ducks in flight go back to the 1400s.

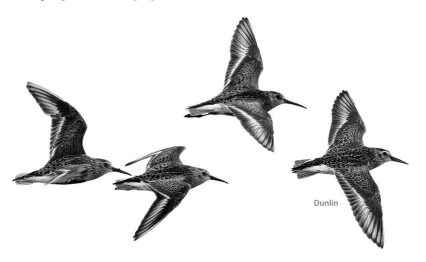

Dunlin

DUNLINS, a fling of . . . Dunlins often form flocks of great numbers that fly in a tight formation with a highly complicated, highly coordinated set of movements that quickly "fling" them through the sky.

EAGLES, a convocation or aerie of . . . An "aerie" is an eagle's nest. A "convocation" is a group called together in a formal way, often for a ceremony, whether academic or religious—and this seems to befit a bird with such a stern, serious expression that we've given it weighty, official symbolic meanings.

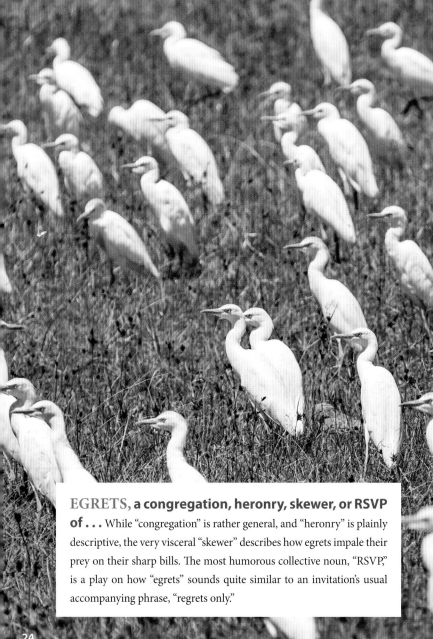

EGRETS, a congregation, heronry, skewer, or RSVP of . . . While "congregation" is rather general, and "heronry" is plainly descriptive, the very visceral "skewer" describes how egrets impale their prey on their sharp bills. The most humorous collective noun, "RSVP," is a play on how "egrets" sounds quite similar to an invitation's usual accompanying phrase, "regrets only."

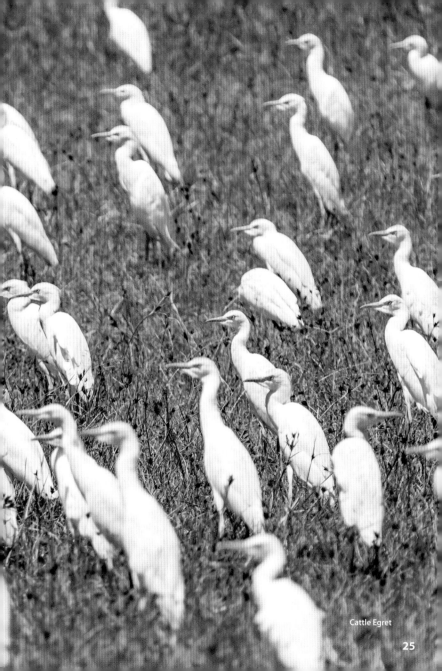

Cattle Egret

EIDERS, a quilt or creche of . . . The eider is famous for its feathers, which are good insulators and help keep its eggs warm in very cold climates. For the same reason, they have long been harvested to fill eiderdown quilts. Perhaps the focus on these warm, soft nests also led to "creche," which doesn't just mean a Nativity scene but is also a word for a nest of foundlings.

EMUS, a mob of . . . Perhaps because of emus' remarkable size and strength, a group of emus might be seen as a little scary, much like a raucous rabble. But it's more likely that "mob" was chosen with its neutral sense in mind: "a crowd or mass."

FALCONS, a kettle, cast, or stooping of . . . Like other birds of prey, falcons have the collective noun "kettle," which might be about their tendency to soar upwards, like steam from a kettle, on thermals. "Kettle" could also be a digression from the old collective noun "cast" (see hawk) via cast-iron, a type of literal kettle. Falcons are famous for their ability to "stoop"—

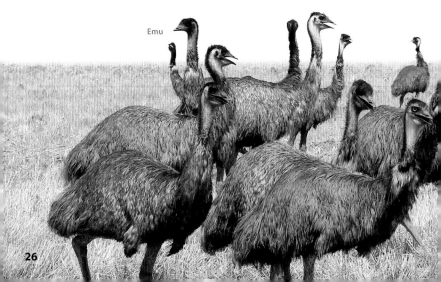

Emu

tuck in their wings and dive downward at such incredible speeds that they literally have third eyelids to keep their vision clear while stooping. (The peregrine falcon's dive makes it the fastest member of the animal kingdom.)

FINCHES, a charm, trembling, or glister of . . .

"Charm" likely has two different etymological roots as a collective noun. As *The Book of Saint Albans* uses it—"A Cherme of Goldefynches"—the spelling indicates a version of "chirm" or "cirm," a word that means "din" or "noise" (and goes back all the way to around the year 800). It's "chirm" that resulted in one modern meaning of "charm": the blended noise of many birds singing at once. But the other, more familiar meaning of "charm"—relating to a magical spell and appealing, attractive attributes—most likely also influenced the collective noun for this charming little bird!

As for "trembling," perhaps it refers to their short, quick movements when flying. "Glister" may be especially used for goldfinches in particular; it means to sparkle and be brilliant, and might be a sneaky reference to Shakespeare's "All that glitters is not gold," from *The Merchant of Venice*.

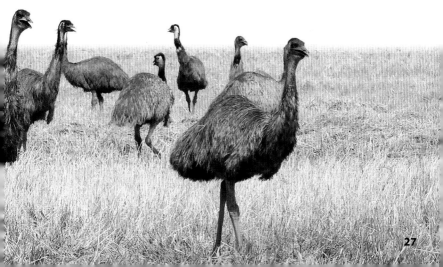

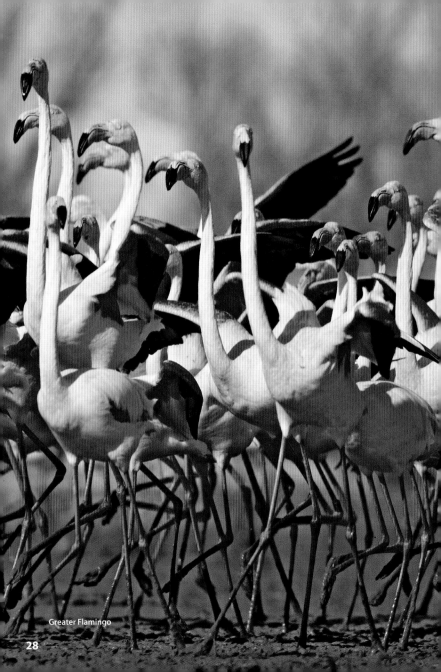

Greater Flamingo

FLAMINGOS, a flamboyance or stand of . . . For a clever collective noun, it's hard to beat "flamboyance," which is both alliterative (it shares a root word—"flame"—with "flamingo") and also evocative: flamingos are definitely brilliantly colored and boldly conspicuous. "Stand" points to the flamingo's famous one-legged stance.

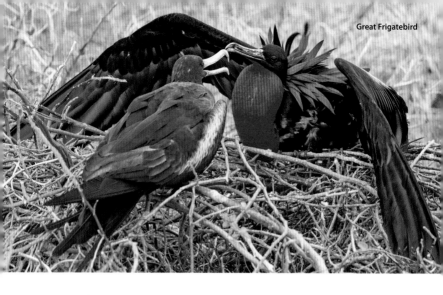

FLICKERS, a guttering of . . . These large and beautifully marked woodpeckers hunt for food and bugs by digging in the ground—and they also love digging in house gutters that are full of winter rubbish.

FLYCATCHERS, a swatting, zipper, or outfield of . . . This family of birds has three collective nouns that play on its name: "swatting" is our common human reaction to flies, "zipper" refers to the fly on your pants, and "outfield" is where baseball players catch fly balls.

FRIGATEBIRDS, a fleet or flotilla of . . . Frigatebirds are swiftly flying seabirds who earned their name from frigates, warships built for speed and maneuverability. Their collective nouns are both references to this, as "fleet" and "flotilla" are groups of ships that sail together in an organized way.

GALAHS, a garrulity of . . . This pink, red, and gray Australian cockatoo is known for its chatty and loud, rather "garrulous" behavior.

GANNETS, **a company, gannetry, or plunging of . . .**

A "gannetry" is a breeding place for gannets, a word that also describes a group of the birds in general. "Company" may be used in the general sense of a group of individuals, or it may be a play on the famous Gannett Company, a large American newspaper syndicate. "Plunging" refers to gannets' hunting technique of diving into water from a height as they pursue fish.

GEESE, **a gaggle, plump, skein, or wedge of . . .** One of the most famous collective nouns, "gaggle" is among the few invented in the fifteenth century that has actually been adopted into common use and is still in use today. In *The Story of English in 100 Words*, David Crystal humorously suggests "gaggle" is the result of the word games of those writing early lists of venery: an intentional perversion of "cackle," with the g's added on a whim to better go with "goose." But the *Oxford English Dictionary* shows that "gaggle," a verb for the call of a goose, somewhat preceded lists of venery like *The Book of Saint Albans* and likely imitated a goose's actual call—it points out that similar imitations of the sound appear in several other languages.

Barnacle Goose

Geese, however, like ducks and a few others, are supposed to be referred to with different collective nouns depending on where the observer sees their group: on land, they are a gaggle, on water they are a plump, and in the air they are a skein or a wedge, which both refer to their characteristic flight shapes. "Wedge" is a more obvious reference to the famous V shape, while "skein" means a bit of yarn or thread—which, like the line of geese in flight, can bend and fold into a V.

GODWITS, a prayer, omniscience, or pantheon of . . .

These birds may have originally gotten their name from an imitation of their call, but that hasn't stopped folks from playing on "god" with religious collective nouns. "Pantheon" is a temple dedicated to all the gods, perhaps an extra clever play on the plurality of gods when a group of godwits convenes.

GOLDENEYES, a wink or 007 of . . .

A "wink" is of course a nod to the bird's eye itself. The website New Zealand Birds has suggested "007" as a fun reference to famous spy character James Bond, who flies again in the 1995 film *GoldenEye*.

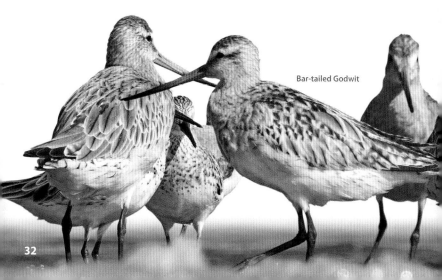

Bar-tailed Godwit

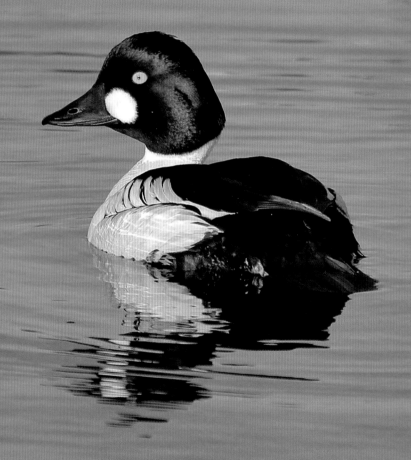

Common Goldeneye

GOSHAWKS, a flight or glare of . . . A hawker would not "cast off" a goshawk from his arm (see Hawk); rather, a goshawk was "lett fli"— which also may be why the goshawk is among the few types of birds to earn "flight" as its collective noun. "Glare" is of course about the look a goshawk will give you with its yellow eyes.

GRACKLES, a cackle of . . . Although a grackle's call is shrill and may sound like cackling, it's also likely that "cackle" is a play on the bird's name (which originates from the Latin *graculus* for a jackdaw).

GREBES, a water dance of . . . Grebes have an elaborate mating display, a "dance" where partners mirror each other's actions, most remarkably including a foot-slapping technique that allows them to rise above the surface and "walk on water" in a show of strength to impress their mates. (It happens to also rather impress us humans.)

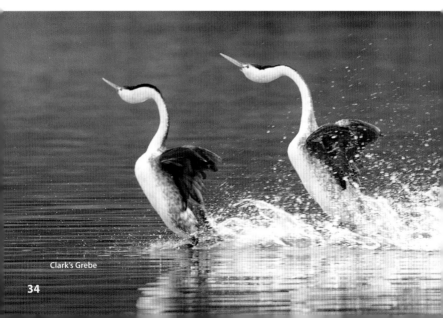

Clark's Grebe

GROSBEAKS, a gross of . . .

The grosbeak's name comes the French for "large beak," and the same French root brought us "gross"—which among other things can mean the quantity of twelve dozen, or anything in bulk or large quantities.

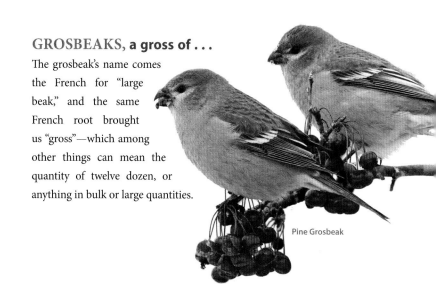

Pine Grosbeak

GROUSE, a drumming or grumbling of . . . The male ruffed grouse's spring courtship displays include sitting on a log and creating a low "drumming" noise by beating the air with its wings in rapid succession, speeding up until it sounds like a motor. Since the 1800s, "to grouse" has also meant "to sulk or grumble" (originating in slang of the British army).

HARRIERS, a swarm or harassment of . . . Both these rather negative collective nouns come from the pejorative verb "to harry," which is to attack, or to annoy or harass. There might also be a connection to the similar verb "to harrow," which means to disturb or distress.

HAWKS, a cast of . . . "Cast" is one of the older collective nouns, from the 1400s, and comes from the way a hawker would "cast off" a bird from his arm in the practice of falconry or hawking (hunting wild animals with a trained bird of prey).

HERONS, a siege, sedge, or pose of . . .
The Book of Saint Albans listed this one, and as other commenters have pointed out, a heron waiting patiently by the water for the moment to strike out and grab an unwitting fish is not unlike the siege of a castle by a patient army. "Sedge" is a word for various rush-like plants that grow in the wet places that herons inhabit. As for a "pose," what else would you call the heron's still, dramatic stance?

Grey Heron

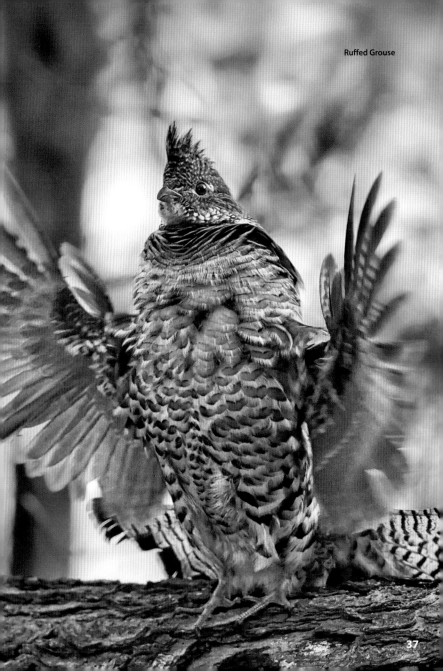

Ruffed Grouse

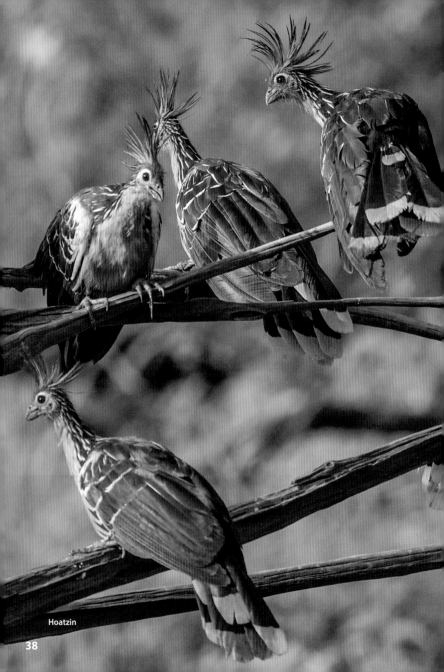
Hoatzin

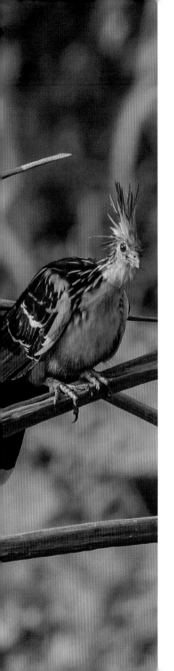

HOATZINS, a dongle of . . . The Amazon's "stink bird" or "reptile bird" is unconventional in many ways, including its leaf-eating diet that is responsible for its pungent smell (often described as similar to cow manure). Hoatzins split from other bird groups a long time ago, evoking the word "dangle". . . factoring in their awkward, flouncing movement and a quirky appearance, it's perhaps no wonder they've earned the quirky "dongle" as their collective noun. ("Dongle" is also a noun for a small device that can be plugged into a computer, which is perhaps seen as an "evolutionary" throwback in the computing era of "the cloud"; we'll leave it up to the reader to speculate on connections there.)

HOUSE MARTINS, a circlage, richness, or swoop of . . .
See Martins.

HUMMINGBIRDS, a charm, troubling, hover, or shimmer of . . . "Charm" is likely borrowed from the collective noun for goldfinches (see Finches)—hummingbirds are, after all, quite charming. "Troubling" is a bit tougher to unpack but perhaps has to do with how territorial hummingbirds can be—they have scared off animals as large as hawks. The hummingbird's famous flying ability (it's the only bird that can hover under its own power) brings us "hover" and the visual "shimmer."

IBIS, a colony of . . . While "colony" is used as a general term for a collection of any kind of bird that is nesting or roosting in one place, ibis have a special association. They form huge colonies (up to 30,000 individuals) and often return to the same nesting sites year after year.

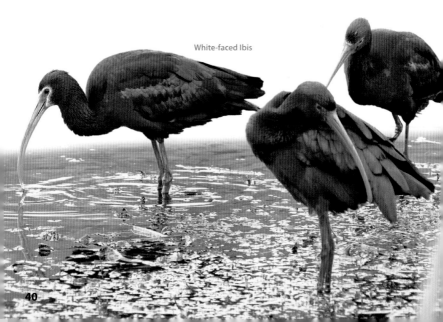

White-faced Ibis

JACKDAWS, a clattering or train of . . . Jackdaws are noisy, and "trains" sure do create a "clattering." It's possible the "clattering" collective noun is also related to the "chattering" of Choughs. See also Crows.

JAYS, a scold, band, or party of . . .

We might call a person who disturbs the peace with his or her constant nagging a "scold," and jays loudly harass other animals to scare away predators and competition. Interestingly, an archaic American slang word for an overly talkative person was "jay." Bands and parties aren't too quiet, either!

Canada Jay

JUNCOS, a junket, jump, or scatter of . . .

While "junket" is likely just a play on the sound of the bird's name, "junket" can mean a merry feast, which perhaps juncos appear to do as they hop ("jump") around on the ground foraging for food. "Scatter," like "jump," is about how they move, especially when approached by a possible predator. See also Sparrows.

KAKAPOS, a booming or island of . . . This New Zealand "owl parrot" is critically endangered, and the remaining population is kept on three predator-free islands by a concerted conservation effort that's been underway since the 1980s, hence the collective noun "island." Kakapos form a unique kind of mating court every three to five years, where the males put on displays to impress the females, who have complete choice of their mates. During this court, called a "lek," the male kakapo constructs a "bowl" in the ground, which he keeps meticulously clear and uses to help amplify the sound of his mating call, which is called the "booming."

KESTRELS, a flight, soar, or hover of . . . Kestrels are among the birds (mostly birds of prey) that have been given "flight" as a collective noun (see Goshawks). "Soar" is unique, and while "hover" is shared with Hummingbirds, the kestrel's "hover" is a little different. Instead of hovering via powered flight, kestrels use their outstretched wings to catch the wind and stay precisely in place.

KILLDEERS, a season, resurrection, or icing of . . . Like Godwits, the killdeer's name comes from imitating the sound of the bird's call, but the way it looks like a compound noun has inspired several punny collective nouns. "Season" plays on deer, of course, while "resurrection" refers to its strategy of feigning injury to draw away a predator from its nest; once the predator is far enough away, the killdeer is suddenly "resurrected" and flies away. As for "icing"—in groups they might cover the ground like icing on a cake, or perhaps someone hungry was taking note of the white streaks on their plumage.

KINGBIRDS, a coronation, court, or tyranny of . . . For a king, a "coronation" is fitting, as is a "court," both fairly obvious collective nouns for such a "regal" bird. Its genus name is *Tyrannus* because they tyrannically defend territory, even attacking much larger birds.

KINGFISHERS, a crown, realm, or clique of . . . Every king needs his "crown," and most kings need a "realm." The best of kings has a "clique" to fill up his court.

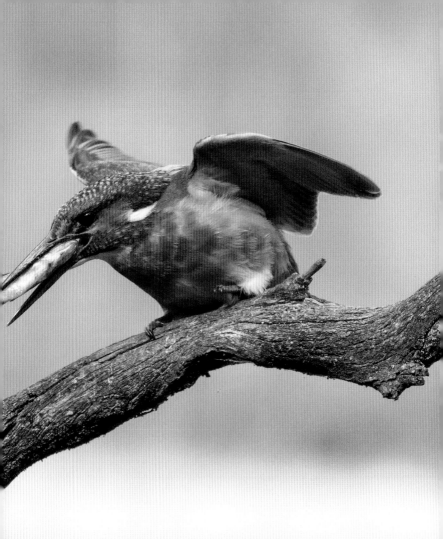
Common Kingfisher

KINGLETS, a castle, princedom, or dynasty of . . . After Kingbirds and Kingfishers, are you tired of the royal wordplays yet? If not, try "princedom," which cleverly imagines a miniature king ("king" + the diminutive suffix "-let") as the king's son, a prince.

KITES, a string or husk of . . . "String" needs no explanation, but "husk" is an uncertain one. Perhaps this collective noun was inspired by the burnt-orange color of the red kite, reminiscent of the husk of some grains and nuts.

KNOTS, a cluster or tangle of . . . Although the birds' name is really of unknown origin (possibly an onomatopoeia of their call), it's fun to consider the debunked, ahistorical theory that they were named after King Cnut the Great, King of Denmark, England, and Norway. As the legend goes, Cnut sagely and humbly demonstrated to his flattering courtiers his inability to stop the tide—a story that later was twisted and told as Cnut believing he had supernatural powers and genuinely trying to stop the tide. The theory was that these birds' tendency to forage in the tide got them named after the king. Basically, it's a messy tangle of non-facts—and knots sure do get into "tangles" and "clusters."

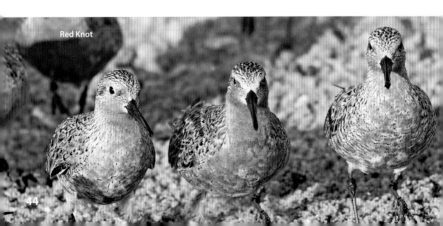
Red Knot

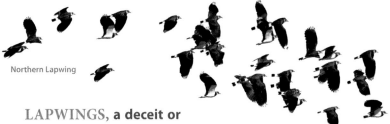

Northern Lapwing

LAPWINGS, a deceit or dessert of . . .

Like "dissimulation" in the case of Titmice, "deceit" refers to the lapwing's antics when trying to draw an unwelcome visitor away from its young in its nest: pretending to be injured and an easy catch for the predator. Shakespeare uses this to great literary effect in *A Comedy of Errors*, having Adriana explain her own strange behavior: "Far from her nest the lapwing cries away." Even Chaucer curses the lapwing in his *Parlement of Foules*: "the false Lapwing, ful of trecherie." A number of sources, though, use "dessert" as the collective noun instead.

LARKS, an exaltation or happiness of . . .

This poetic collective noun has gotten a fair amount of attention, partly because it goes all the way back to *The Book of Saint Albans*—it even forms the title of James Lipton's book of terms of venery (yes, the James Lipton of *Inside the Actors Studio*). To "exalt" is to raise in rank, honor, character, or power, and the lark certainly shows off its rise into the air with its extravagant, melodious in-flight calls. To "exalt" also once meant to "elate" with happiness, as surely the sight and sound of these birds might do to us. A "lark," in the sense of a merry escapade, might also bring on much "happiness."

LINNETS, a parcel of . . .

"Parcel" has been used as a generic collective noun—for people, animals, things—since the 1400s. It's not clear why parcel is assigned to linnets, but perhaps it's because linnets feed on flax, the plant used to produce linen, which is used when wrapping "parcels."

LOONS, a cry, asylum, or water dance of . . . The loon's distinctive, eerie call gives us the obvious collective noun "cry." That call, when paired with their erratic behavior when escaping danger, inspired the common phrase "crazy as a loon," which in turn gave us the collective noun "asylum" (see also Cuckoos).

On occasion loons do upright "dances" on water, sometimes for courtship or to guard their nests, hence the "water dance" (see also Grebes).

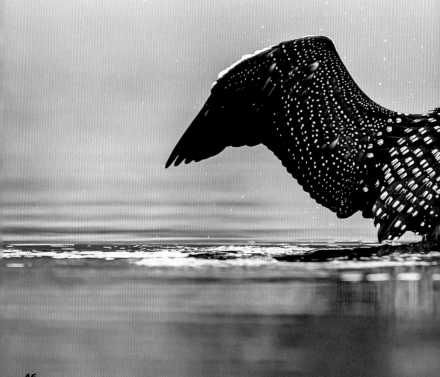

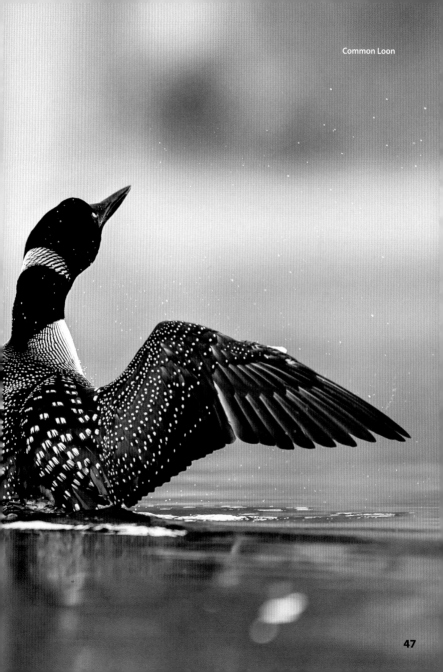

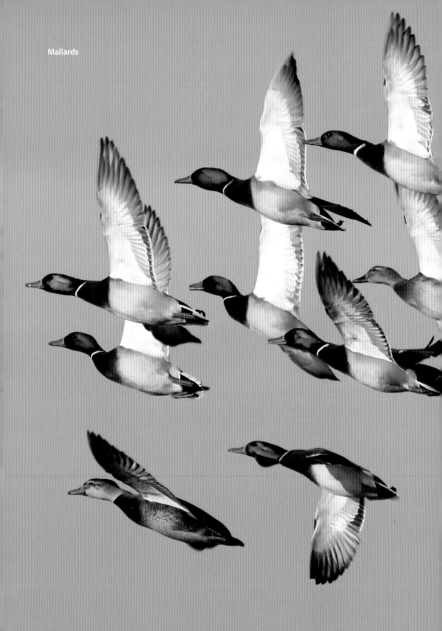

Mallards

MACAWS, **a cry or endangerment of . . .**

These parrots' call, the loud "caw" straight from their name, is highlighted by "cry." There are many species of macaw, some of which are already extinct and a few that are critically endangered. Their status inspired "endangerment," which is an example of people playing the word game of collective nouns in a rather pointed way (for comparison, see Dodoes). See also Parrots.

Blue and Gold Macaw

MAGPIES, **a tidings or mischief of . . .** In
superstition, the sight of a lone magpie would bring bad luck, while other specific numbers of magpies would tell other specific futures—so the sight of a group of magpies would bring "tidings." Magpies also have the reputation of collecting shiny objects, even stealing jewelry, and in different places are associated with witchcraft or death—explaining the "mischief" to say the least."

MALLARD, **a sord, flush, or suit of . . .** "Sord" was
perhaps originally a verb for these birds' action of rising or soaring upward, but after the word's inclusion in a number of "proper" lists of terms of venery, it really only has meaning as the collective noun for mallard. "Flush" similarly originally meant to fly up suddenly—an onomatopoeia for the sound wild ducks make when rising from water. "Suit" may have originated from the male mallard's unique coloring, which includes a white "collar" and body that contrast from its head. Interestingly, but probably unrelated: all three of these words also have some relation to playing cards: swords held by the Kings (though "sord" has an entirely different etymology than "sword"), four suits to make a deck, and a flush hand all of one suit. See also Ducks.

MARTINS, a circlage, richness, or swoop of . . . Martins feed on insects caught in midair, and their flight patterns may have originated "swoop" and "circlage." "Richness" might refer to the rich, royal blue or purple of their coat, or perhaps simply their abundance when in a group.

Purple
Martin

MEADOWLARKS, a pod of . . . These small birds might evoke a pea pod or other seed-bearing legume or fruit, and indeed they do eat seeds in addition to their main diet of insects. But it's more likely "pod" has been borrowed as the collective noun often used for a group of dolphins or whales.

MERLINS, a leash or cast of . . . In *The Book of Saint Albans*' section on falconry, these hawks were noted to be "for a lady," presumably because they were smaller. "Leash" refers to hawking equipment, and while "cast" is also a falconry term (see Hawks), it could also have stuck because the wizard Merlin surely "cast" a spell or two.

MOCKINGBIRDS, an echo, plagiary, or ridicule of . . . The mockingbird earned its name for the way it mimics other birds' songs and other sounds—like an "echo" or someone who "plagiarizes." The loud volume and rapidness of its mimic leaves the impression of mockery or "ridicule."

NIGHTHAWKS, a kettle of . . . Nighthawks perhaps deserve something more creative, but for now they have a common, traditional collective noun used for various birds of prey: kettle. (See Falcons.)

NIGHTINGALES, a watch of . . . A traditional folk tale tells of a one-eyed nightingale and a one-eyed blindworm who were friends. The

nightingale was invited to a wedding and was ashamed to go with one eye, so the blindworm let the bird borrow its eye so it could have two. But after the wedding the nightingale didn't want to return the eye, so the blindworm promised revenge. This, according to the tale, is why the nightingale keeps itself awake all night, singing, on a nightly "watch."

NUTCRACKERS, a suite or ballet of . . . An allusion to the famous Tchaikovsky ballet *The Nutcracker*, which is of course not about a bird, but a German wooden doll who comes to life. The music you probably know today as *The Nutcracker* is actually a 20-minute "suite" of the ballet's music that Tchaikovsky arranged for a concert performance.

NUTHATCHES, a jar of . . . This one seems to be a simple play on the "nut" part of the bird's name—we might keep a jar of nuts in our kitchen.

ORIOLES, a pitch, split, or phoenix of . . . The Baltimore baseball team has inspired two of these baseball-related collective nouns: "pitch" is of course the basic beginning of each play; "split" could be referring to the "split-fingered" type of fastball pitch, or a player's "splits," their performance statistics when broken down into categories. The Baltimore oriole itself (the state bird of Maryland) is sometimes called a "firebird," which in turn inspired the mythical bird "phoenix" as a collective noun.

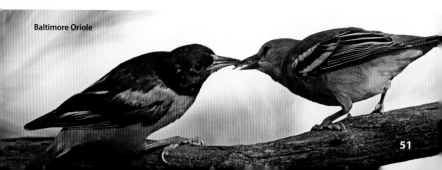
Baltimore Oriole

OSPREYS, a duet or piscation of . . . These hawks usually mate for life, inspiring "duet," though using "duet" to refer to a group of more than two could get confusing! "Piscation" means fishing, or a fishery, a suitable word for a bird that eats fish almost exclusively.

OSTRICHES, a wobble or pride of . . . These famous flightless birds may appear to "wobble" sometimes, with their large bodies on long, skinny legs. But they aren't too clumsy—they have the fastest land speed of any bird (up to 43 miles per hour) and are the fastest two-legged animal! They also have earned the collective noun "pride," most often associated with lions—perhaps because they share habitats with lions as well as other predators like cheetahs, leopards, African hunting dogs, and spotted hyenas. No wonder they run so fast.

OWLS, a parliament, wisdom, or sagaciousness of . . .

Chaucer was probably the first to use "parliament" as a collective noun for a group of noisy birds in general. In early uses, it was more often used for a group of rooks (see Rooks). But its use for a group of owls picked up steam as a rhyming play on the title of Chaucer's poem *Parlement of Foules*, and also because it captures something about the way we see owls in popular culture: wise, perhaps pompous, and absolutely capable of meeting in a conference to noisily discuss and argue over plans. The widespread knowledge of this collective noun can also be credited to a development in the 1950s: in *The Chronicles of Narnia*, C.S. Lewis creates a council of owls who meet

at night to discuss the affairs of Narnia, which is literally called "The Parliament of Owls." Since the huge international success of the Narnia books, this term has become one of the most popular and most used collective nouns.

This hasn't stopped other wordsmiths from suggesting other possibilities, though: "wisdom" and "sagaciousness" both seek to capture our Western ideas of these birds as particularly shrewd, but perhaps miss some of the depth of imagery of "parliament."

PARAKEETS, a chatter or chattering of . . . Like choughs, these birds are noisy, so it's no surprise they were given the same collective noun, "chattering." It may even be a better fit for parakeets than for choughs, who earned it first, if only because parakeets, unlike choughs, can be taught to repeat human words, so they can literally chatter.

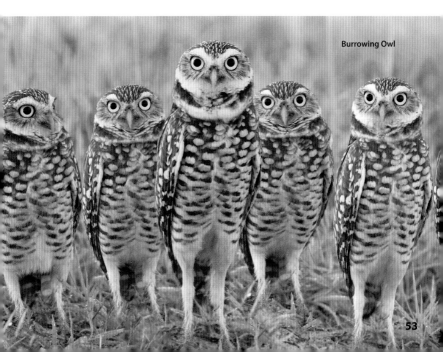

Burrowing Owl

PARROTS, a pandemonium or prattle of . . . Parrots are famous for being able to imitate human speech, and they can generally be noisy—earning them the talkative "prattle" and the alliterative, uproarious "pandemonium." (It's safe to assume these charismatic birds have gotten "pandemonium" from its general modern sense of unrestrained chaos—not its original meaning as the abode of all the demons, as used by Milton in *Paradise Lost*.)

PARTRIDGE, a covey of . . . This is an old one, from *The Book of Saint Albans*, and literally means a brood or hatch of partridge. "Covey" came to Middle English by way of an Old French word for "hatch," which in turn came from the Latin word *cubare*, which means "to recline" and is also the root word of "concubine" and "incubate."

PEACOCKS, an ostentation or muster of . . . "Muster" dates back to *The Book of Saint Albans* (and before) as a word for a general assembly of people or things—particularly when those people or things are put on display. (That meaning of "muster" is now mostly associated with soldiers standing for inspection: "to pass muster.") In the 1920s, a new collective noun was found for peacocks that captured their colorful, proud display of feathers: "ostentation."

PELICANS, a squadron of . . . A "squadron" is a portion of a naval fleet of ships, but it's not just the aquatic association that brought pelicans this collective noun. There have been numerous ships named after the bird, including sixteen British Royal Navy ships, three US Navy Ships, and the galleon that Sir Francis Drake sailed around the globe in 1577–1580 (*Pelican* was its original name; Drake re-named it *Golden Hind* mid-voyage).

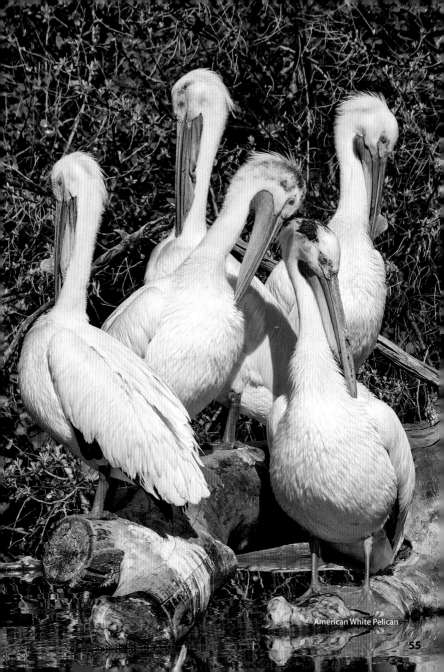

American White Pelican

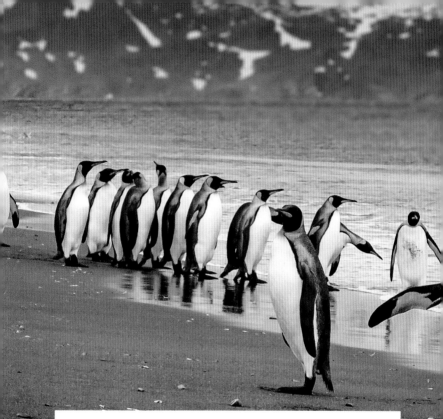

PENGUINS, a waddle, huddle, or parade of . . .
As portrayed to great comic effect in a number of animated movies, penguins walk with a distinct "waddle," using their tails and wings to keep their balance in their upright stance. "Parade" is also likely a (delightfully alliterative) reference to how that waddle looks when a big group all walks across land together. Emperor penguins are also famous for "huddling" together to conserve heat in the frigid Antarctic. They are so efficient at this that they have to switch positions; the birds on the outside get too cold, but the birds on the inside actually get too hot!

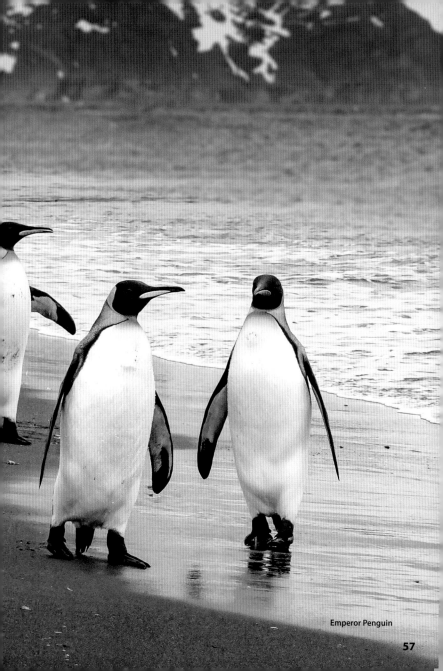

Emperor Penguin

PHALAROPES, a swirl, twirl, whirl, or whirligig . . . All of these collective nouns refer to these shorebirds' unique way of feeding: they swim in a tight, fast circle and create a small whirlpool that will stir up the insects and crustaceans they feed on. The first three words, in various etymologies, refer to the rotating motion of a whirlpool—but "whirligig" is a word that's nearly as old. It has been used to describe tops and other "whirling" toys since the 1400s.

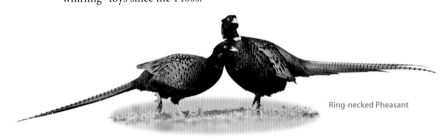

Ring-necked Pheasant

PHEASANT, a nye or bouquet of . . . Early lists of terms of venery all listed "ny" or "nye"; the *Oxford English Dictionary* notes the variant "eye," also used specifically for a brood of pheasant. "Bouquet" is more recent and a lovely reference to these birds' colorful plumage.

PHOENIXES, a myth of . . . Like the collective noun for Dodos, this one was of course (and rather self-referentially) invented as part of a word game.

PIGEONS, a kit, dropping, or stool of . . . "Kit" is a general collective noun meant to represent the whole number of something, viewed as a whole or a set (as in the phrase "the whole kit and caboodle"). It's been used for groups of pigeons, particularly when in flight, since the late 1800s. "Dropping" is the humorous complaint of the city dweller who has found himself walking through pigeon excrement one too many times. "Stool"

is a reference to the famous expression "stool pigeon," a phrase for police informers who perhaps hung out on stools in bars (and were reminiscent of the dead decoy pigeons set out by hunters to lure other birds near).

PLOVER, a congregation or wing of . . . For whatever reason, in the early lists of terms of venery, only two groups got the term "congregation": people and plovers. "Wing" may seem unspecific—but mysteriously, no other type of bird seems to share this as a collective noun.

POCHARDS, a rush or knob of . . . "Rush" probably refers to these ducks' forceful, flowing movement when they dive for food, while "knob" is probably inspired by the round, reddish-brown head of the male pochard. See also Ducks.

PTARMIGAN, an invisibleness of . . . Rock ptarmigan wear camouflage no matter the season: their feathers molt to white for winter and brown for spring and summer. It makes them, if not "invisible," quite difficult to see.

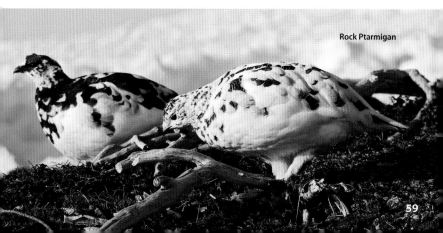
Rock Ptarmigan

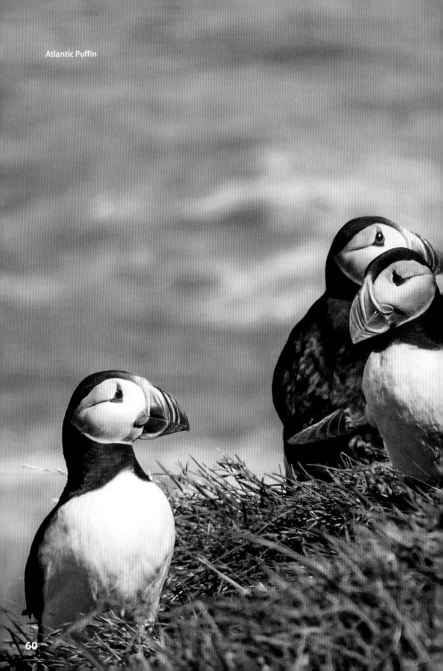

Atlantic Puffin

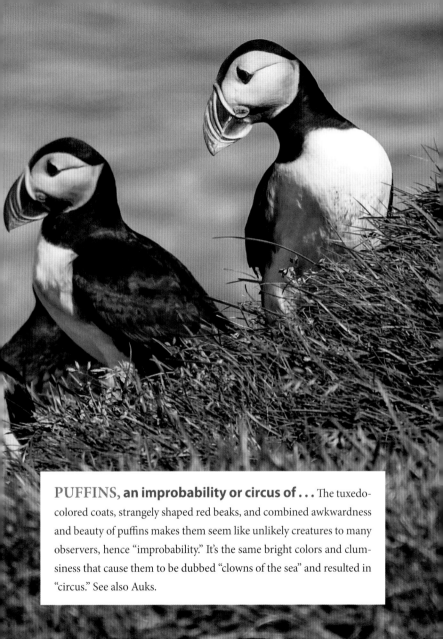

PUFFINS, an improbability or circus of . . . The tuxedo-colored coats, strangely shaped red beaks, and combined awkwardness and beauty of puffins makes them seem like unlikely creatures to many observers, hence "improbability." It's the same bright colors and clumsiness that cause them to be dubbed "clowns of the sea" and resulted in "circus." See also Auks.

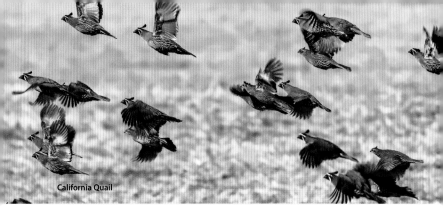

California Quail

QUAIL, a bevy or drift of . . . In *The Book of Saint Albans* and other early lists of terms of venery, "bevy" was the correct collective noun for a group of quail, a group of roe (deer), and a group of ladies or maidens. (Today "bevy" can be used as a collective noun for any kind of company.) Unlike most game birds, quail are strongly migratory, and "drift" is the word used for the influence of wind currents on migrating birds.

RAVENS, an unkindness, conspiracy, storytelling, or tower of . . . The famous collective noun "unkindness" (or as it was spelled in *The Book of Saint Albans*, "unkyndenes") refers to an old legend that ravens push their young out of the nest, leaving them to survive on their own. "Conspiracy" is similarly negative, reflecting their frequent association with death (see also Crows). "Storytelling" refers to the tremendous number of stories, legends, and fables from all over the world that involve ravens—today, one of the most famous stories is the narrative poem "The Raven" by Edgar Allan Poe. A famous superstition holds that when no ravens live at the Tower of London, the Crown and Britain "will fall"—so at least six ravens are kept there at all times, tended to by the official Ravenmaster and inspiring the collective noun "tower."

REDPOLLS, a gallup or gallop of . . . This collective noun is a play on the "poll" in these birds' name, based on the famous polling and analytics company, Gallup, started by George Gallup in 1935. "Gallop" is of course a common verb and homonymic variant of "gallup."

ROADRUNNERS, a marathon or race of . . . Human runners run "races" and "marathons." Roadrunners have been clocked running at speeds of 20 mph, much faster than the average human speed of 10 to 15 mph (though Usain Bolt has been clocked at 28 mph in the 100-meter sprint).

Greater Roadrunner

ROBINS, a round, hood, christopher, bobbin, or worm of . . .

Robins have inspired a number of original collective nouns. "Round" is a reference to the phrase "round robin," which has taken on a number of meanings over time, from a disparaging name for the consecrated Eucharist host, to certain kinds of fish and flowers, to a petition with the signatures written in a circle to disguise the order of signing, to a type of sports tournament. The next two are references to names of popular characters, Robin Hood and Christopher Robin; "bobbin" simply appears to have stuck because it is a fun rhyme, while "worm" refers to robins' legendary food of choice.

ROOKS, a building, clamour, or parliament of . . .

Rooks' pickiness when creating their nests inspired the term "building," which goes all the way back to *The Book of Saint Albans* (rooks prefer to break branches and twigs off trees or steal them from others' nests rather than take them from the ground). Rooks' loud, shout-level caws inspired "clamour."

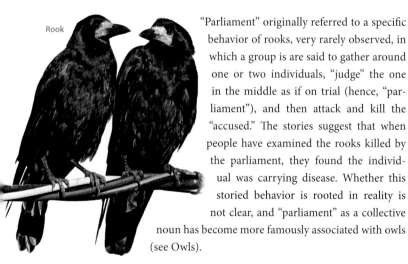

Rook

"Parliament" originally referred to a specific behavior of rooks, very rarely observed, in which a group is are said to gather around one or two individuals, "judge" the one in the middle as if on trial (hence, "parliament"), and then attack and kill the "accused." The stories suggest that when people have examined the rooks killed by the parliament, they found the individual was carrying disease. Whether this storied behavior is rooted in reality is not clear, and "parliament" as a collective noun has become more famously associated with owls (see Owls).

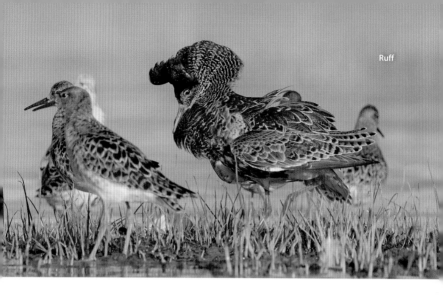
Ruff

ROOSTERS, a crow or cacophony of . . . While roosters are competitive and unlikely to form all-male groups, and the collective nouns for chickens would undoubtedly apply to this species regardless of the gender, humans have nonetheless suggested these humorous, ear-splitting collective nouns for roosters. (See also Chickens.)

RUFFS, a hill or collar of . . . It's unclear how "hill" came to be associated with ruffs, other than they certainly might cover a whole hill: on their wintering grounds, one flock (or "hill") might contain hundreds of thousands of birds. Meanwhile, the male breeding plumage of the ruff earned the bird its name, because the neck feathers look remarkably like the large, frilly ornamental "collar" garments worn in Elizabethan and Jacobean times—ruffs.

SANDPIPERS, a time-step of . . . When sandpipers run, their skinny legs move as fast as a tap dancer's, which is perhaps why their collective noun refers to the rhythm-setting step at the beginning of a tap dance.

SAPSUCKERS, a slurp of . . . A "slurp" is the sound one makes while sucking—these birds may or may not make any such noise when sucking the sap from trees, but it's a catchy collective noun.

SEAGULLS, a squabble or scavenging of . . . Any beach visitor can attest to the "squabbling" sounds that can be heard from seagulls fighting over scraps of food. And of course they're "scavenging" birds—this collective noun originates in Thomas Pynchon's 1973 classic *Gravity's Rainbow*."

SHELDUCKS, a dopping of . . . This term is from the early lists of venery, when these birds were all still called "sheldrakes," and when to "dop" meant to dive or sink suddenly into water, which makes it an apt description of these ducks' behavior when they're avoiding predators. Incidentally, "dop" also came to mean "a short curtsy" a few hundred years later (in the 1500s)—it's pleasant to imagine the shelducks' escape as a quick curtsying away.

SHOVELERS, a crew or graveyard of . . . Those who shovel might form a "crew," or dig graves in a "graveyard." See also Ducks.

SKIMMERS, a scoop or embezzlement of . . . These birds skim the surface of the water in order to "scoop" up small fish and other food. Humans who "skim" some of their employers' funds for themselves are committing "embezzlement."

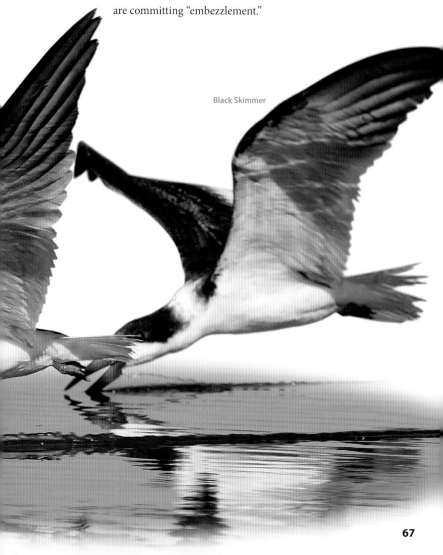

Black Skimmer

SNIPES, a walk or wisp of . . . Snipes most often move by walking, hence "walk." They are so adept at camouflage and escape that they are very difficult to hunt, which has inspired hunting challenges and the word "sniper," which originally meant a master marksman, able to hit the snipe. It's the snipes' fluttery, difficult-to-spot deception among marshy land that made someone think of the glowing ghost light called a "will-o'-the-wisp."

SORAS, an ache or whinny of . . . One of the soras' calls is described as a descending "whinny." "Ache" is a play on the bird's name, which sounds similar to "sore."

SPARROWS, a host, quarrel, or ubiquity of . . . *The Book of Saint Albans* listed a group of sparrows as a "host," a word that originally meant a large army or warlike gathering. This perhaps represents sparrows' reputation as destructive pests. Many species of sparrows are also noisy and will compete for food, which has earned them "quarrel." "Ubiquity" comes from the fact that sparrows are plentiful and common, including in human environments, making them among the most well-known wild birds in the world.

STARLINGS, a murmuration, clutter, or constellation of . . . Starlings have impressive vocal abilities and can make a host of different calls, songs, and imitations of other birds and sounds—so it's interesting that

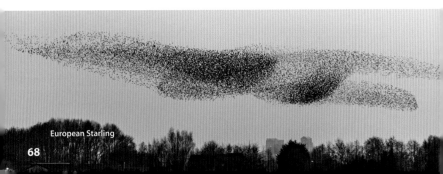
European Starling

lists of venery like *The Book of Saint Albans* associated them with a mere murmur ("murmuration"). The word has really taken hold, however, and is especially used to describe the tight masses of hundreds of starlings that move as one in intricate flight patterns—a quite remarkable sight that is as interesting to physicists as to biologists, who are still studying how this works.

Because starlings are quite common and considered to be an invasive species, they may seem to "clutter" the environment. "Constellation" is a play on the "star" in their name.

STORKS, a mustering or phalanx of . . .

Both of the storks' collective nouns have military associations, and in the wild, stork behavior can seem martial at times. The European stork has a stiff, rigid posture, almost as if it were at attention, and other storks some-time feed in lines, or take off or land in formation. "Muster" is a word that originally meant "to show" (see Peacocks), but came to mean the action of an army coming together for an inspection or battle preparations. "Phalanx" is a word from ancient Greece for a group of tightly packed lines of infantry, which would move with their shields joined together.

Wood Stork

SWALLOWS, a flight or gulp of . . .

Early lists of terms of venery called a group of swallows a "flight," a collective noun only shared with a few other birds—the others are birds of prey (see Goshawks, Kestrels), and it's unclear why swallows earned this distinction. "Gulp" is a more modern one, a delightful play on the verb "swallow."

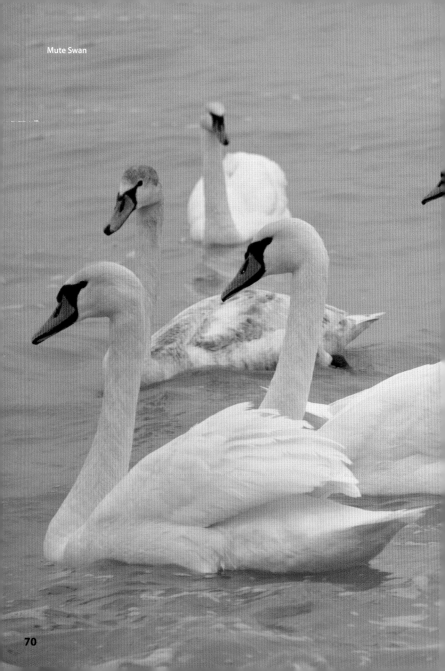

Mute Swan

SWANS, a wedge, eyrar, ballet, lamentation, or regatta of . . . Swans evoke a number of symbolic meanings to humans, which is perhaps why they've inspired so many different collective nouns, none of them distinctly more popular than the rest. The somewhat uninspired "wedge" has been borrowed from geese, similarly meant to be used only when the group of swans is spotted in flight in the V formation (see Geese). "Eyrar" is an old word, a derivative of "eyrie" which specifically meant a brood of swans. "Ballet" and "lamentation" are both musical references: ballet of course refers to Tchaikovsky's world-famous *Swan Lake*; "lamentation" is probably a reference to the "Swan's Lament" melody used in church services and popular from 850 to 1100. A "regatta" is a boat race, and is perhaps meant only for swans seen on water—it may have especially been chosen for its similarity in sound to "regal," which certainly describes the posture of a swan.

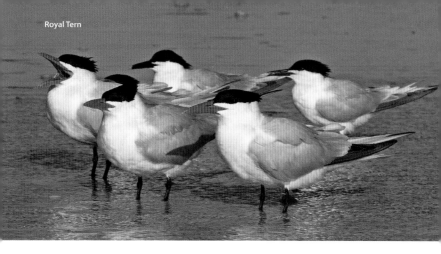
Royal Tern

SWIFTS, a swoop or screaming frenzy of . . . Since swifts are highly aerial birds (flying for months at a time, they hold the record for longest continuous flight) and can fly quite fast (second in speed only to the peregrine falcon), it's no surprise that they've been called a "swoop." Their calls are high-pitched and loud, a veritable "screaming frenzy" when in a group.

TEAL, a spring of . . . In *The Book of Saint Albans*, terms for game were listed for the purpose of hunting, so this one (spelled "a Sprynge of Telis" at the time) described the behavior of the birds when they were flushed and fleeing: they would "spring" up.

TERNS, a cotillion of . . . Male terns court their partners through displays and ritualized fighting, calling to mind the rituals and showing-off of a cotillion ball and the dances done there.

THRUSHES, a mutation or hermitage of . . . It's unclear where "mutation" comes from—James Lipton's *An Exaltation of Larks* claims it's from an ancient Greek piece of folklore held that thrushes grew a new set

of legs every decade, casting off the old ones. "Hermitage" is likely inspired by the name of one species of thrush, the hermit thrush.

TITMICE, a banditry or dissimulation of . . . Perhaps tits are "bandits" because of the tricky way they learned to peel off caps of bottles left by the milkman and raid them for the cream! Or perhaps they're a "dissimulation" from their protective behavior when a predator approaches the nest: they pretend to be injured, crying and imitating a broken wing in order to draw the stranger away from their young.

TOUCANS, a durante of . . . Toucans have very large beaks and a croaking call; this collective noun is a reference to Jimmy Durante, a famous vaudeville, radio, and television comedian with a large nose (which he called "the schnozzola") and a gravelly voice.

Toco Toucan

TOWHEES, a tangle or teapot of . . . Towhees are often found in "tangles" or thickets; "teapot" is likely just a lovely alliteration, but it could be said the whistle of a teapot has a pitch similar to the call of a towhee. (Plus, they're about the same size, and both have a round little belly!)

TUIS, an ecstasy of . . . These beautiful New Zealand passerine birds have vocal ranges akin to parrots and produce calls that are variously full of chortles, clicks, creaks, groans, and sweet notes. A singing tui uses the movement of its whole body to achieve these sounds, nodding and throwing its shoulder forward in apparent enthusiasm and even joy—bringing the listener as well as the bird, perhaps, to ecstasy.

TURKEYS, a rafter or gang of . . . Although it may be fun to picture a line of turkeys on a beam inside a barn or building, this "rafter" is actually from one sense of the word "raft": a large number of something (also related to "raff," which you may recognize in "riffraff"). "Gang" is similarly generic here, meaning simply "a collection of things or people" and first used to describe herds of animals in the 1600s.

VIRGINIA RAILS, a reel of . . . This waterbird got its collective noun from the similar-sounding "Virginia reel," a folk dance most popular in the US from 1830 to 1890.

VIREOS, a peal of . . . This collective noun was given to Bell's vireo (and all other species of vireo with it) to play on the pealing sound of a bell.

VULTURES, a wake, kettle, or committee of . . .
When a group of vultures is in flight, it's a "kettle" (perhaps related to "kettle of fish," see also Falcon); when a group is resting on the ground or in trees, they're a committee (one thinks of the indecisive characters from Disney's *The Jungle Book*). But when a group of vultures is feeding, their scavenger status and association with death is highlighted: it's a "wake."

WAGTAILS, a volery of . . . "Volery" or "volary" was an old term for a large birdcage or aviary; it's not clear why wagtails were assigned this collective noun over other birds that may have been kept in aviaries.

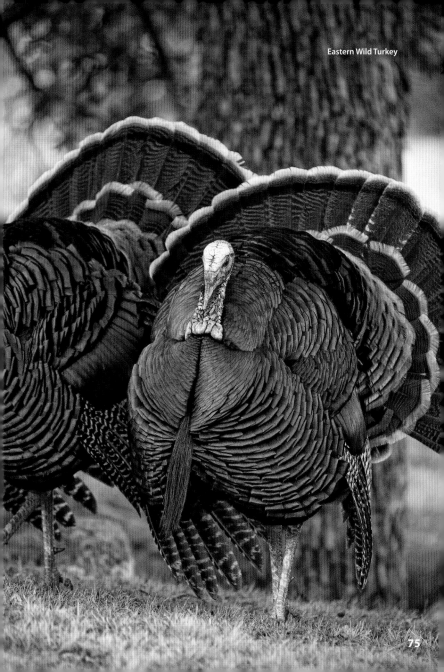

Eastern Wild Turkey

WARBLERS, a wrench, corsage, or bouquet of . . .

"Wrench" is a violent, twisting motion or an abrupt turning movement—which generally characterize these small birds' movements. "Bouquet" and "corsage" emphasize just how colorful many warbler species can be.

WATERFOWL, a raft, bunch, or knob of . . . This is quite a

big category of birds—the idea is that if you don't know a more specific collective noun for a waterbird, you could use these more generic collective nouns. "Raft" is the most obviously water-related among these. "Bunch" is indeed a generic-sounding one, as we might use it for various types of collected people or things, but it has also been assigned quite specifically to waterfowl—a notable early use was by the poet Michael Drayton in the second part of his massive topographical poem "Poly-Olbion," published in 1622. Meanwhile, the 1875 Manual of British Rural Sports specified that a "knob" was a group of waterfowl, but only when there are less than 30 birds in the group.

WAXWINGS, a museum of . . . Waxwings earned their name

from the fact that the red tips of some of their wing feathers look like the color of sealing wax. "Museum" is a play on wax museums, which display wax sculptures of famous people and have entertained people for centuries.

Bohemian Waxwing

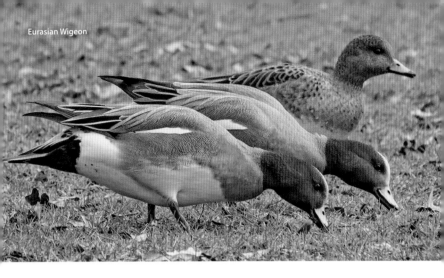
Eurasian Wigeon

WHIP-POOR-WILLS, an invisibility of . . . While slightly different from the collective noun for ptarmigan, it's basically the same concept: whip-poor-wills' incredible camouflage makes them extremely difficult to spot.

WIGEONS, a scry or smidgen . . . A "scry" is a 1400s word for a shout or clamour, which you may certainly hear from wigeons—the male's call is more of a whistle, while the female's is more of a grunt or growl. "Smidgen" may or may not necessarily mean a small number of wigeons, as it seems to have been chosen mainly for the fun rhyme.

WOODCOCKS, a fall of . . . This collective noun was one of the terms of venery found in *The Book of Saint Albans* and refers to the way that woodcocks appear suddenly during migration times: one day there won't be any, but the next day they will fill the bushes, as if they fell from the heavens. We think it's probably best this bird has an old, well-established collective noun and doesn't need any new wordplay around its name.

WOODPECKERS, a descent, dive bomb, drumming, or gatling of . . . "Descent" is from an early list of terms of venery, for the way that woodpeckers swoop down quickly; "dive bomb" is simply a modern iteration of the same concept. "Drumming" and "gatling" refer to the bird's characteristic rhythmic pecking, which sounds similar to the rapid-fire of a Gatling gun.

WRENS, a herd or chime of . . . Only a few birds on early lists of venery were given the collective noun "herd," which was usually used only for cows and other bovine animals—it's been suggested that the wren was given this honor for being (according to folklore) "the king of birds." The wren's high, melodious call may have evoked the melodious "chime" as a more distinctive collective noun.

RECOMMENDED READING

Berners, Juliana. *The Boke of Saint Albans*. 1486. Accessed via Hathi Trust Digital Library: https://catalog.hathitrust.org/Record/001758387

Crystal, David. *The Story of English in 100 Words*. New York: Picador, 2013.

Lipton, James. *An Exaltation of Larks: The Ultimate Edition*. New York: Penguin, 1993.

Oxford University Press. *The Oxford English Dictionary, USA edition*. Oxford: Oxford University Press, 2010.

Woop Studios. *A Zeal of Zebras: An Alphabet of Collective Nouns*. San Francisco: Chronicle Books, 2011.

INDEX